# CONNECT & COLOR

# WORLD LANDMARKS

# CONNECT & COLOR

# WORLD LANDMARKS

## AN INTRICATE COLORING AND DOT-TO-DOT BOOK

Racehorse Publishing

# Dot-to-Dot Guide

◆ = Stop line here and look for next section

○ = Begin new section

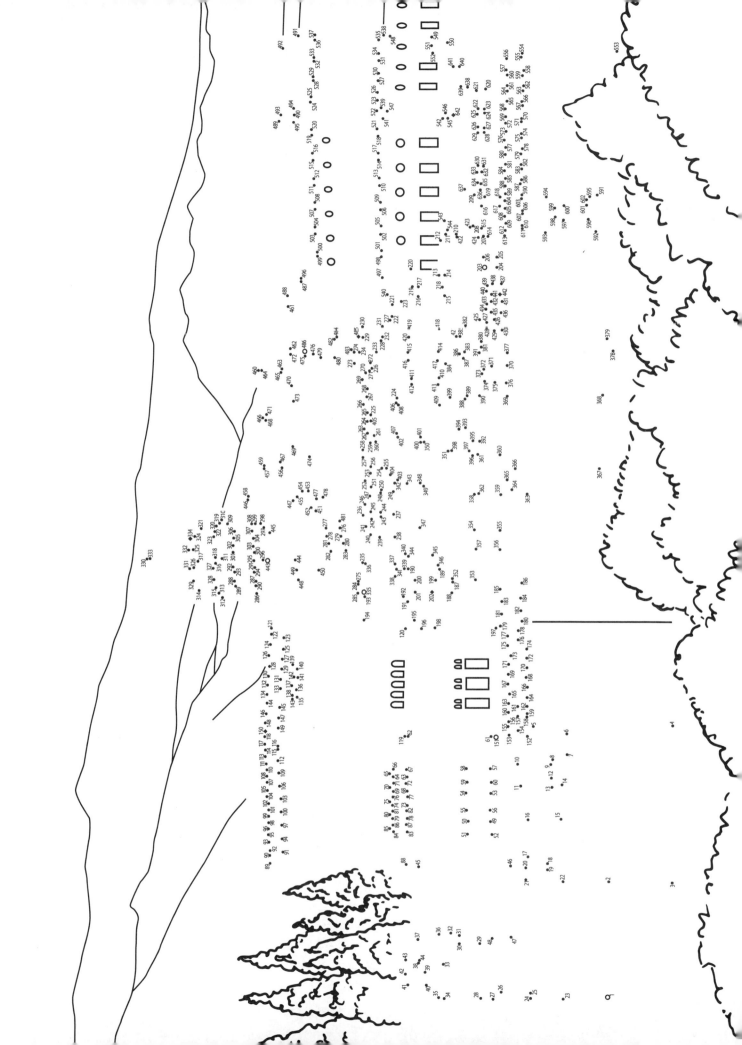

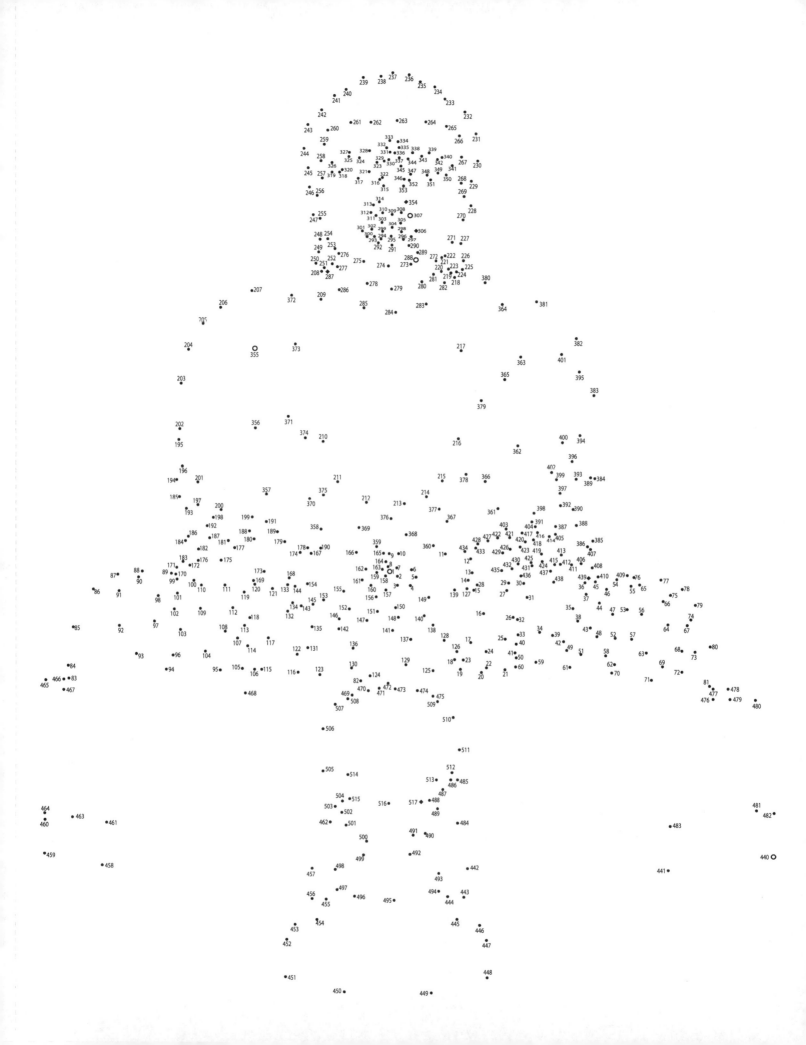

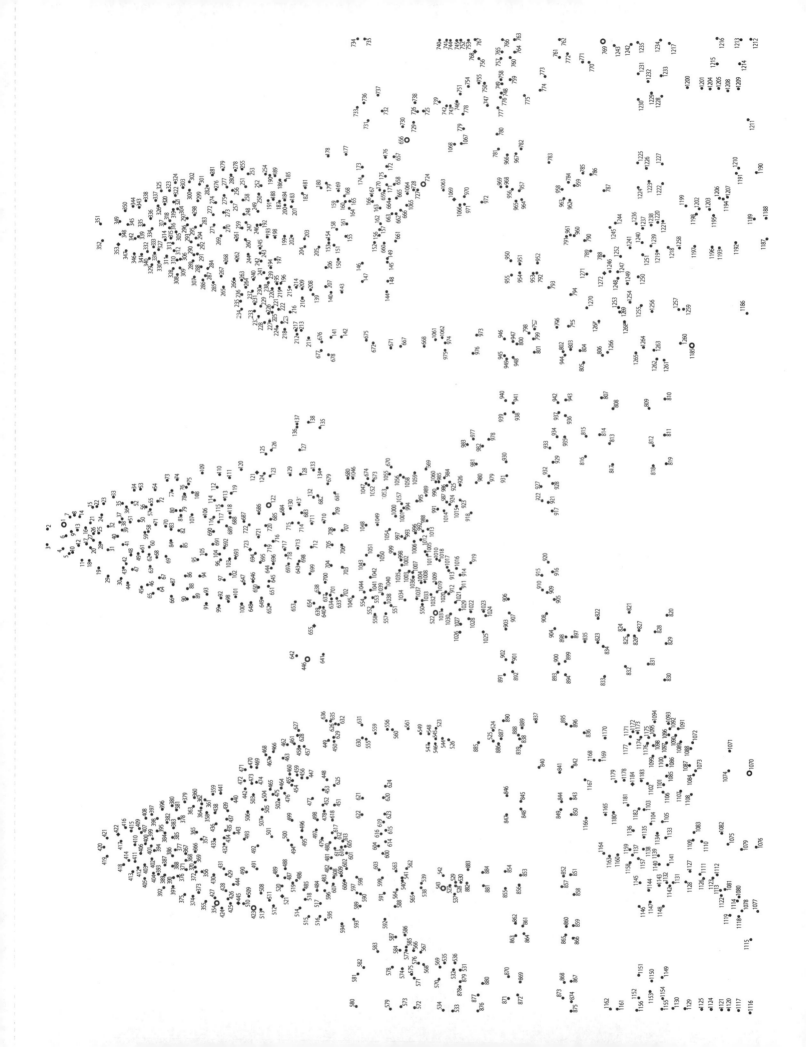

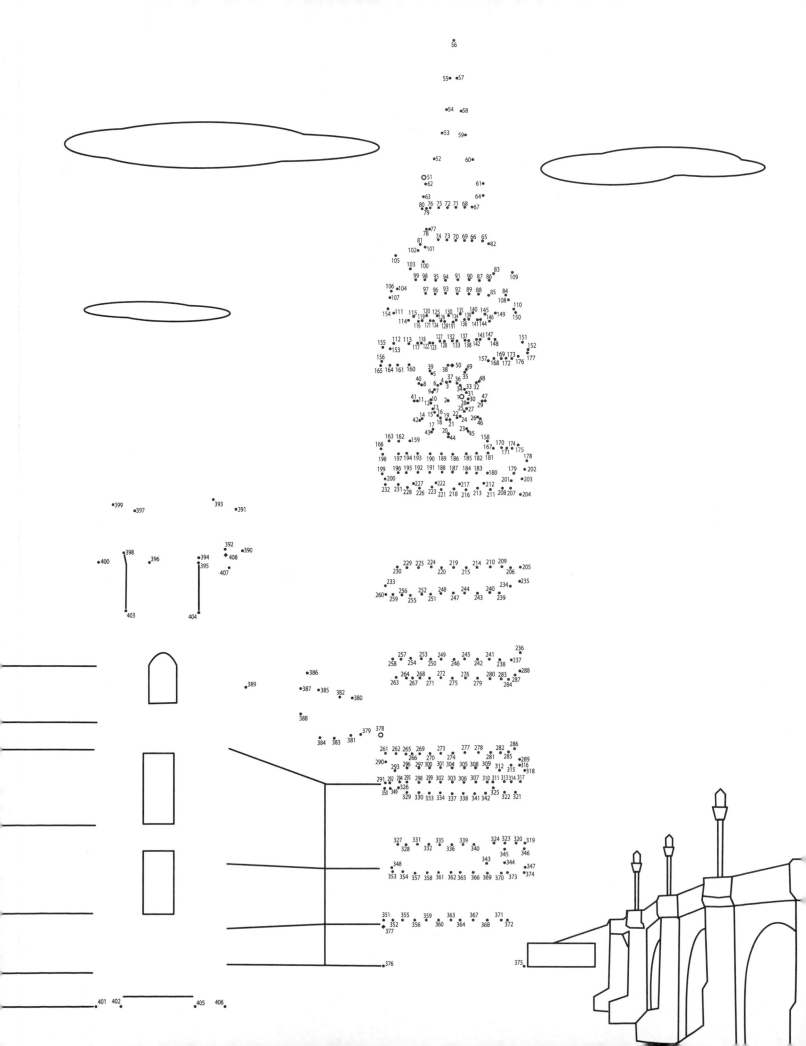

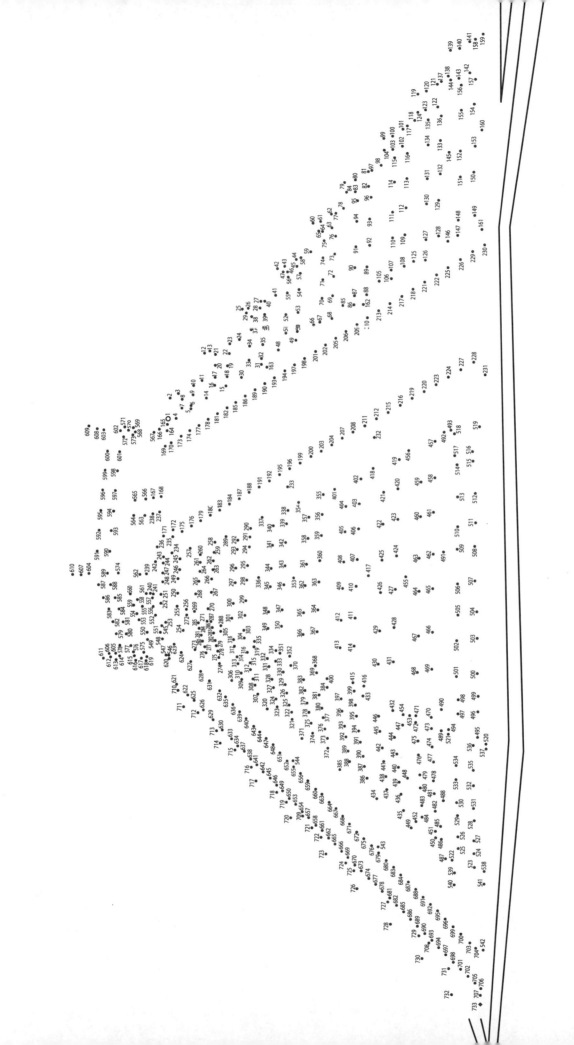

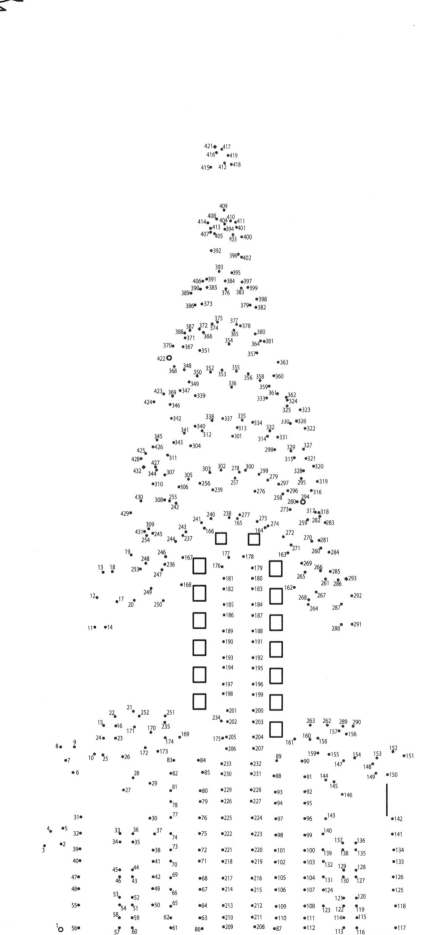

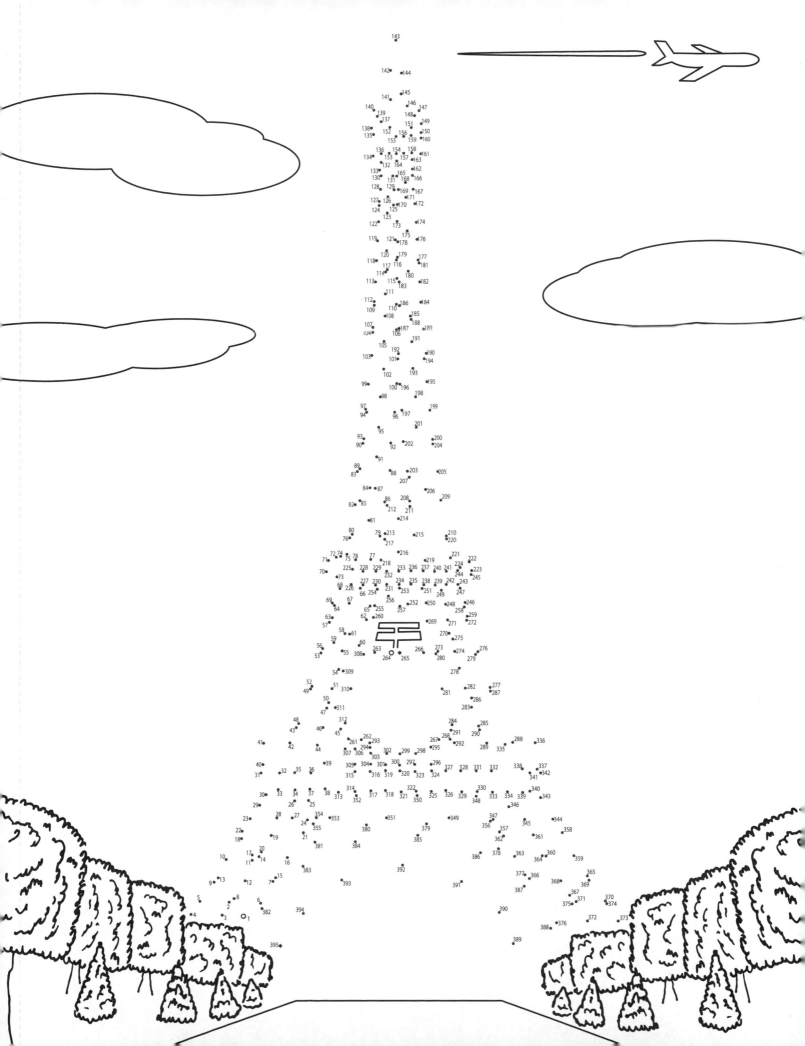

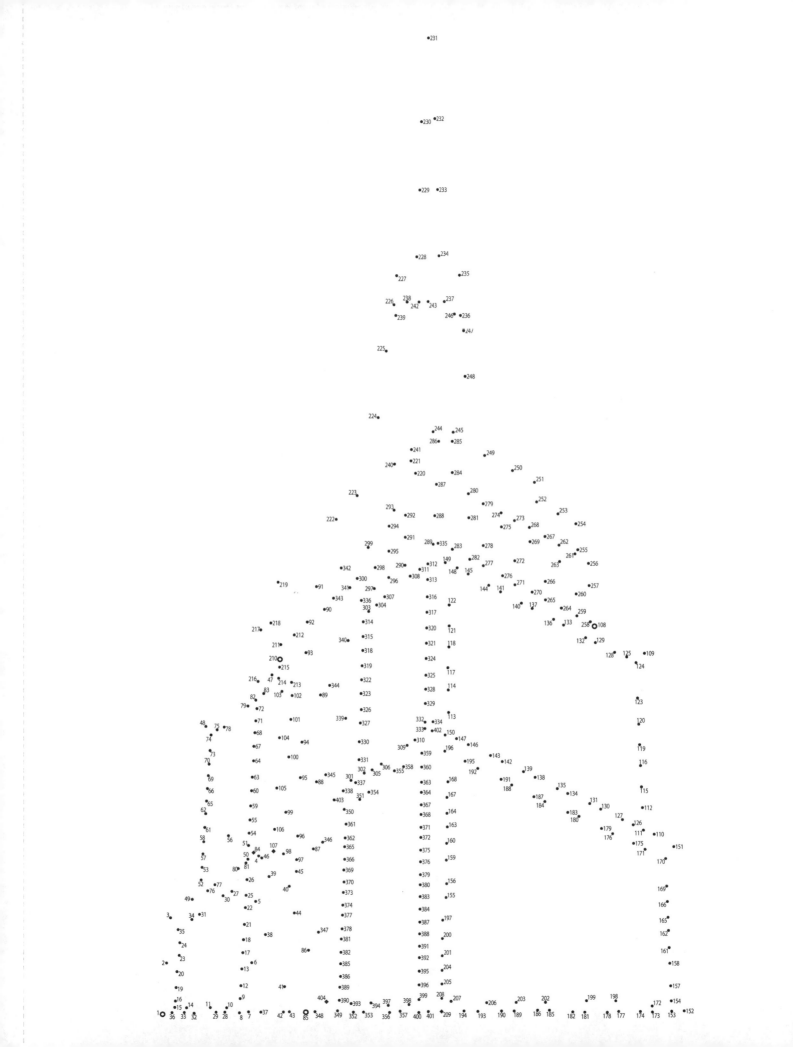

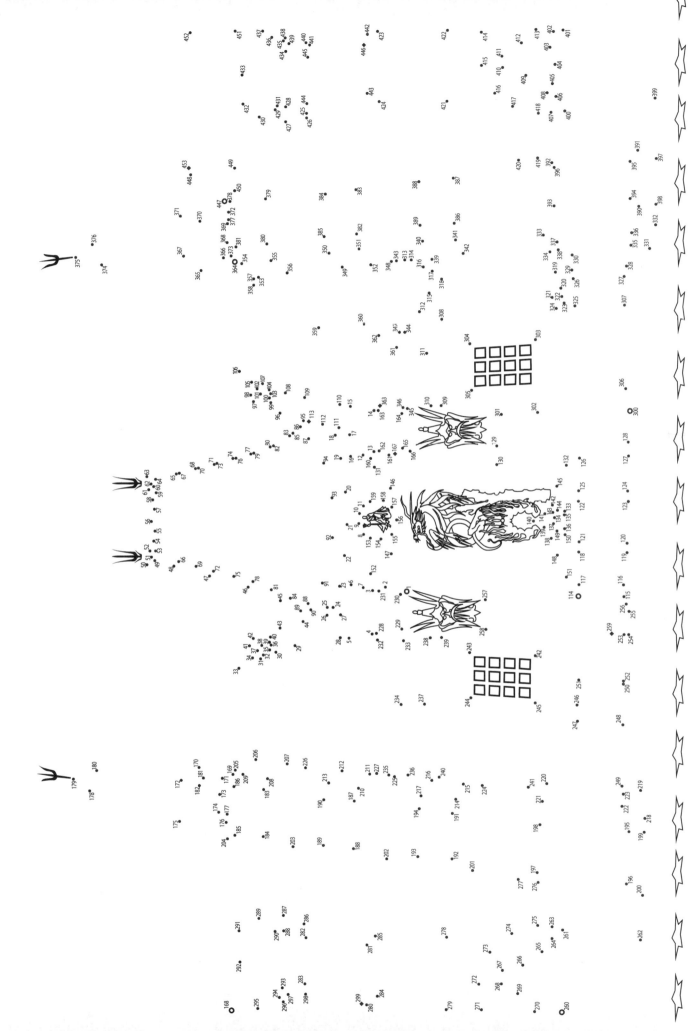

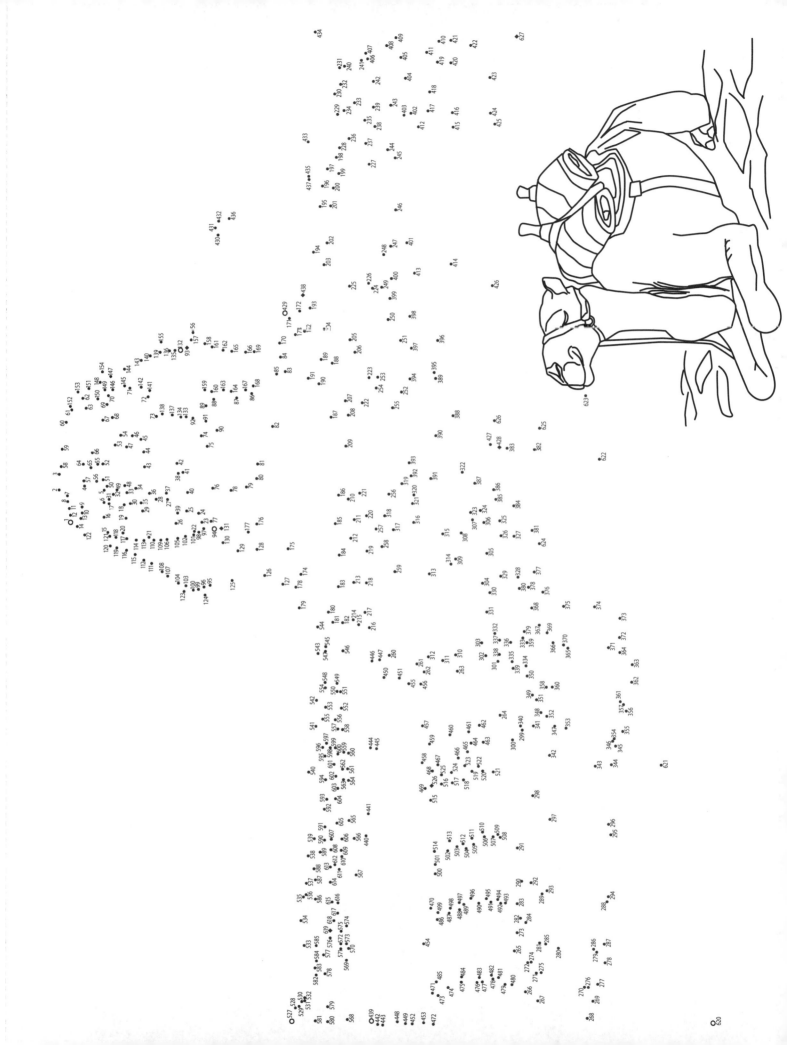

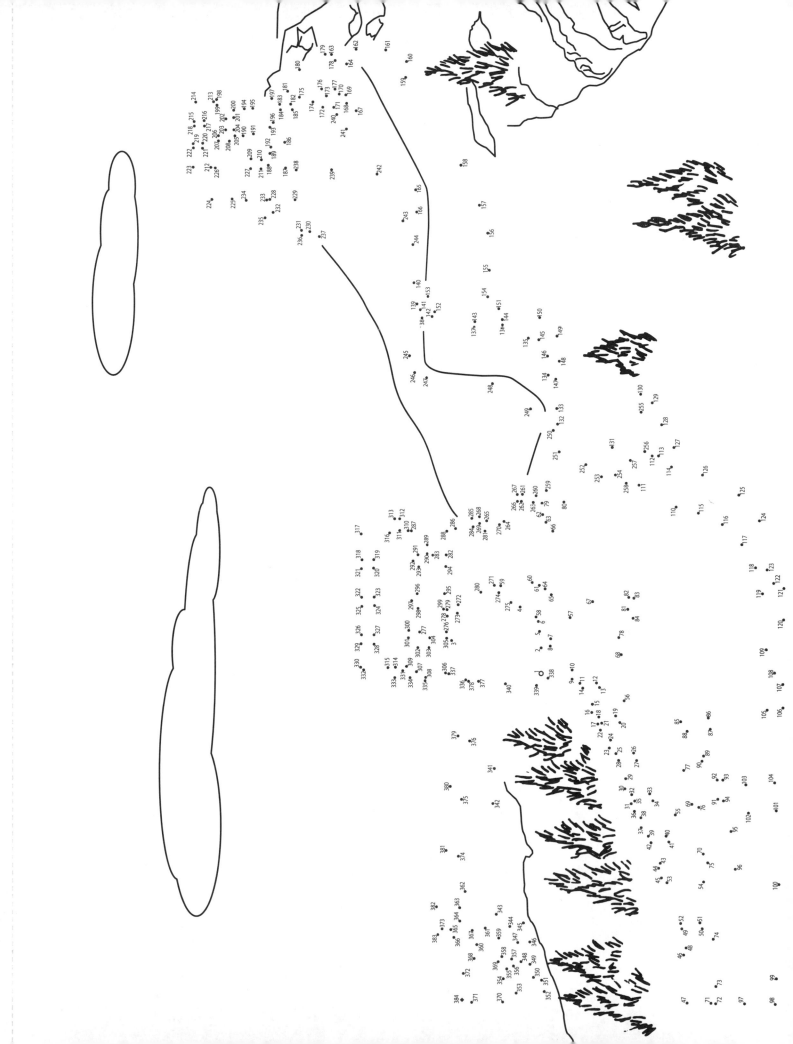

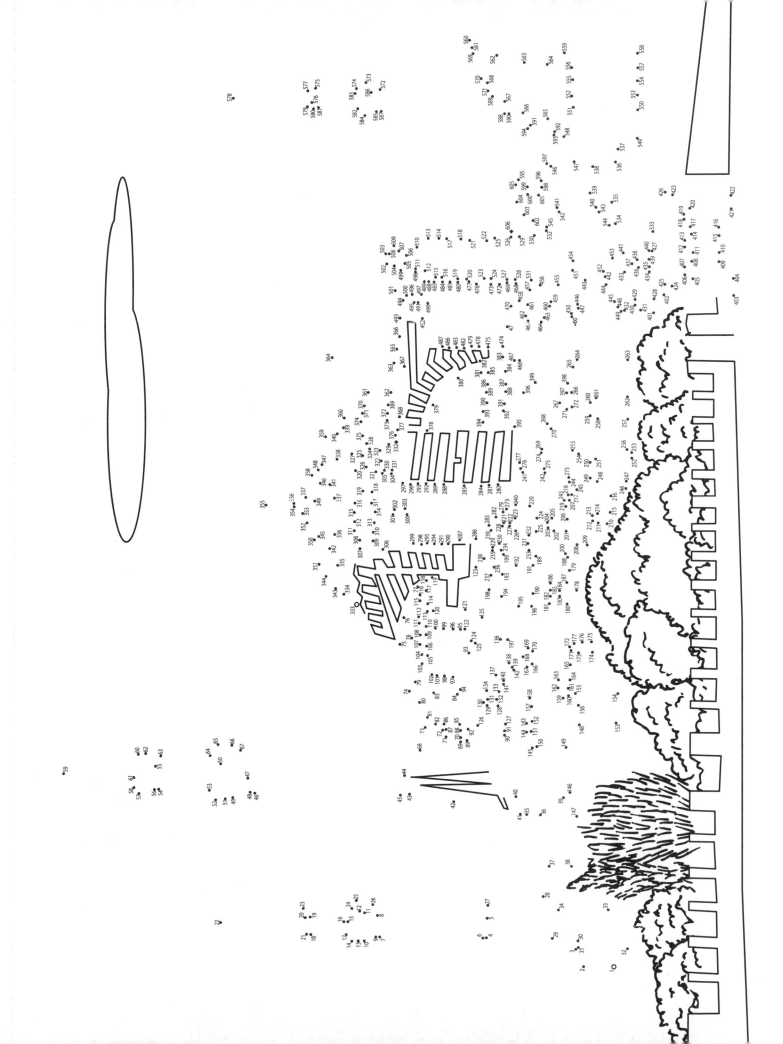

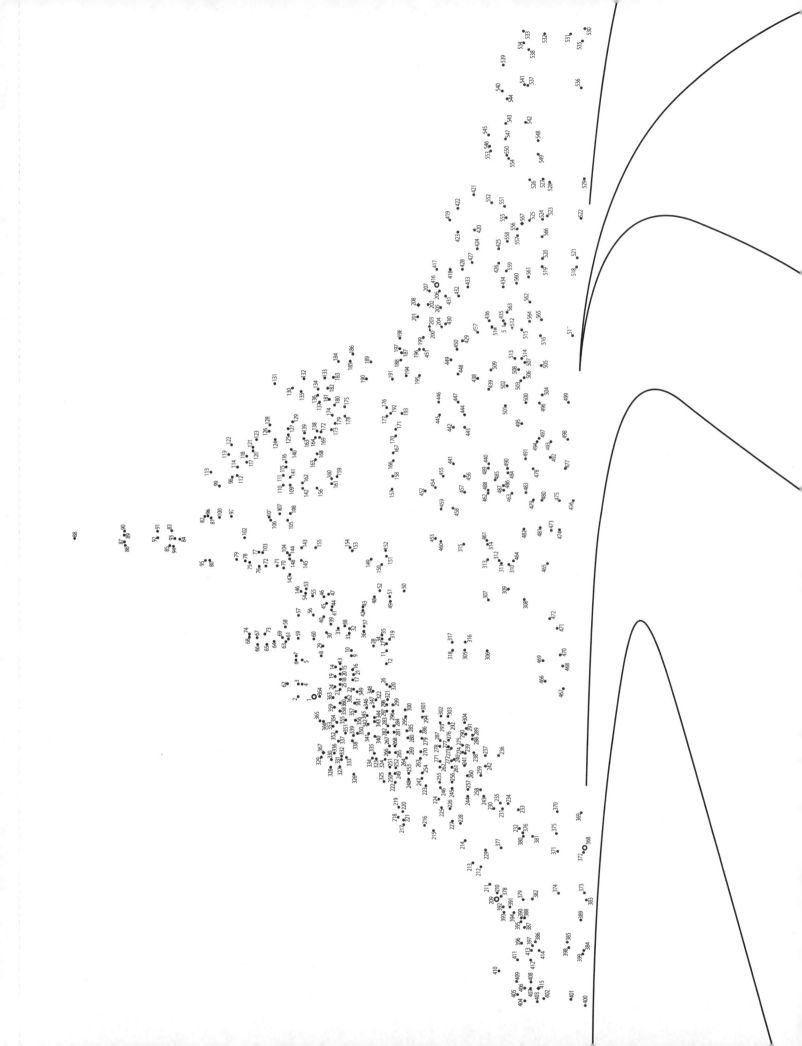

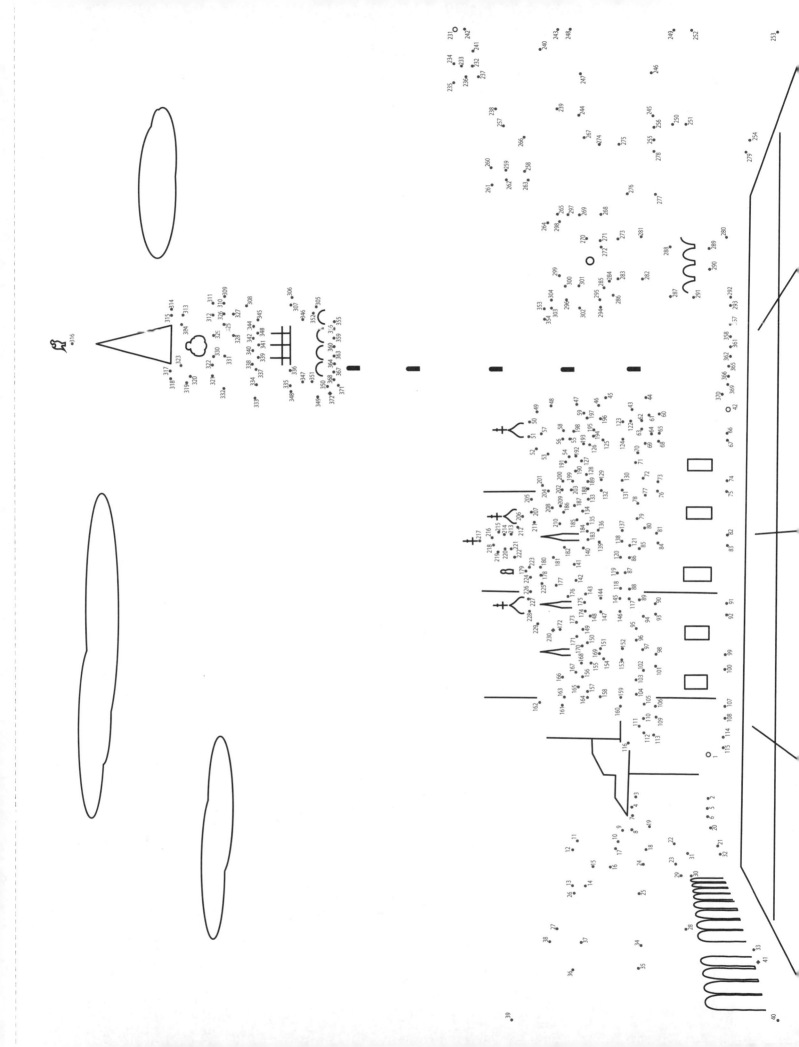

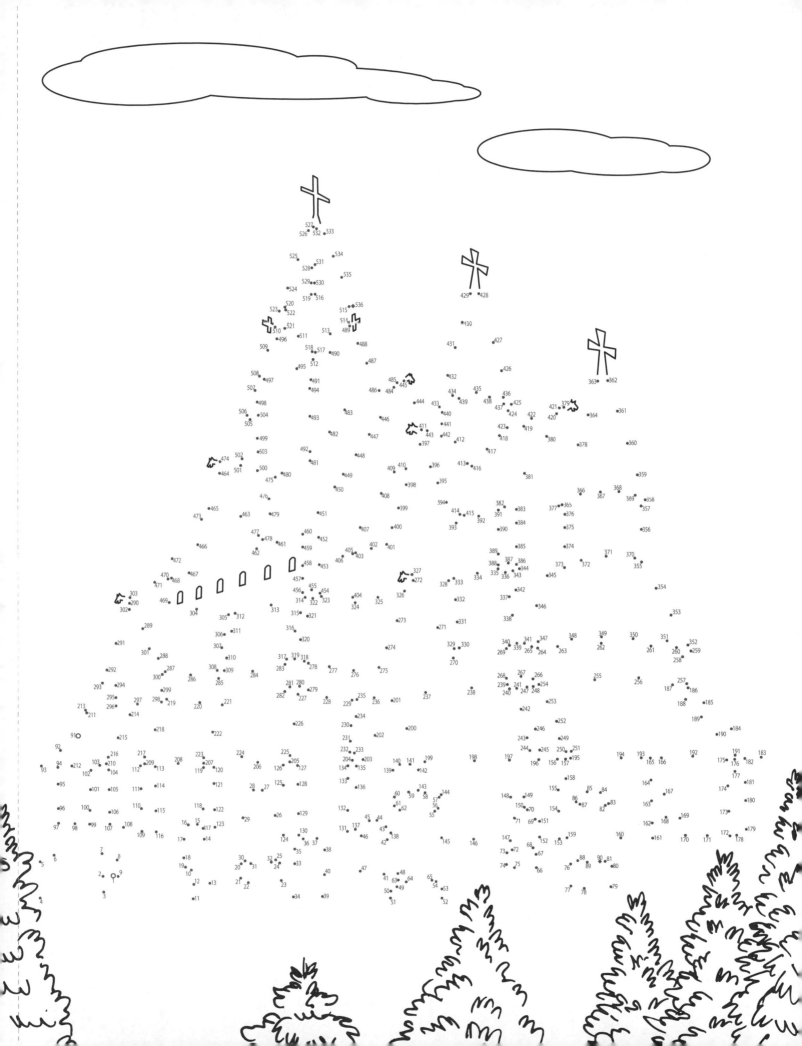

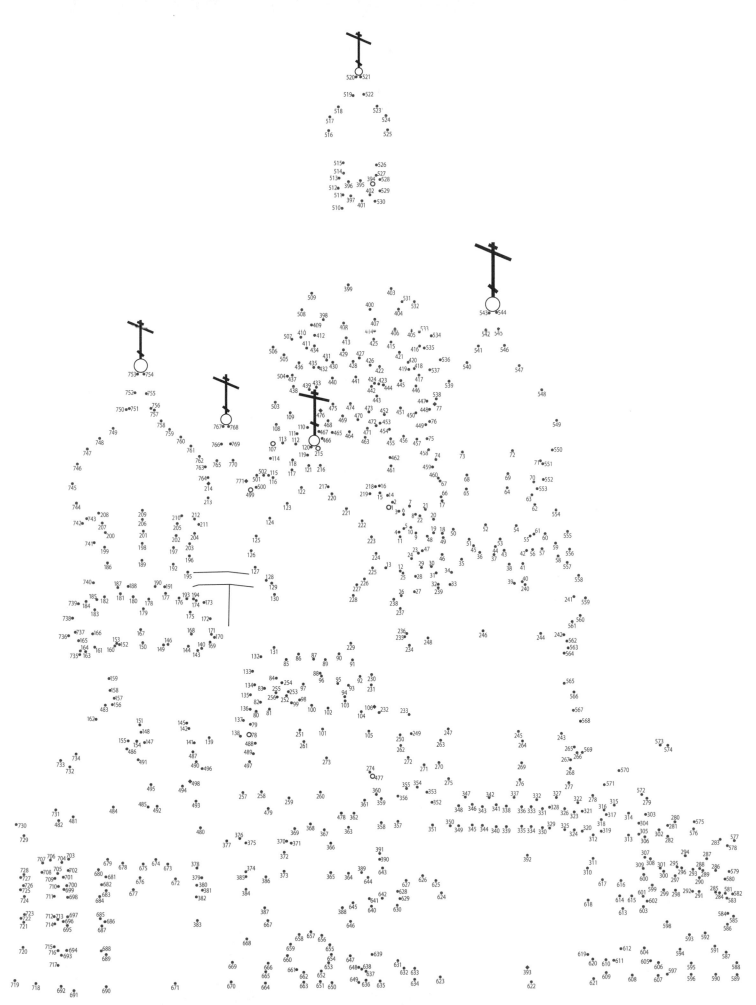

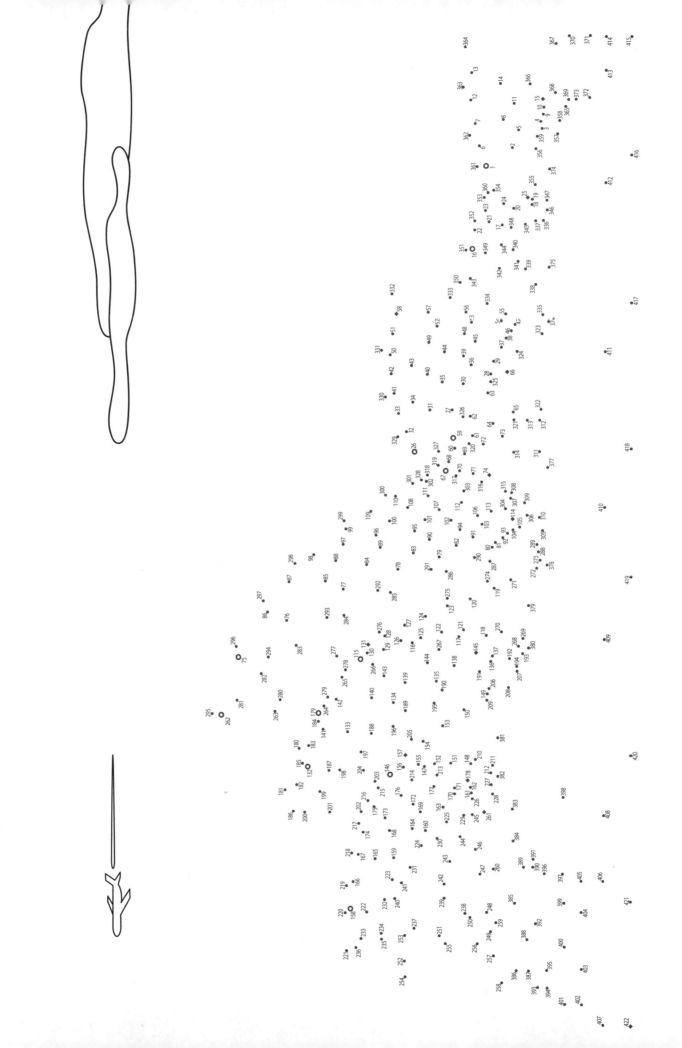

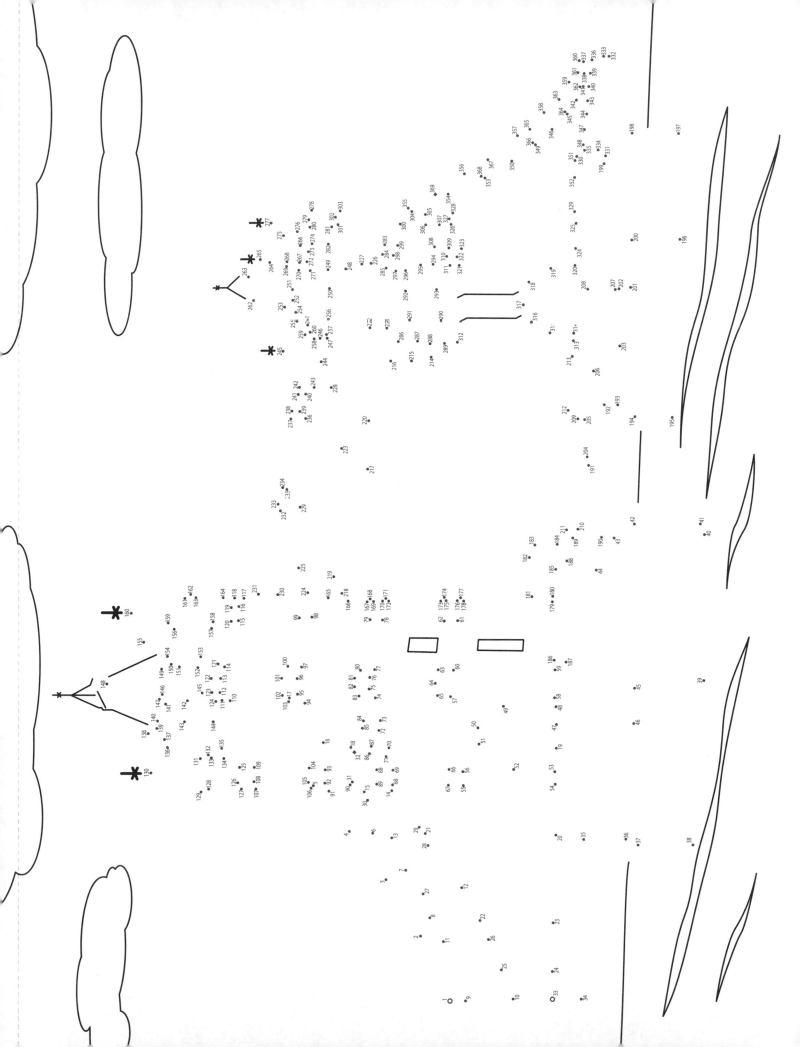

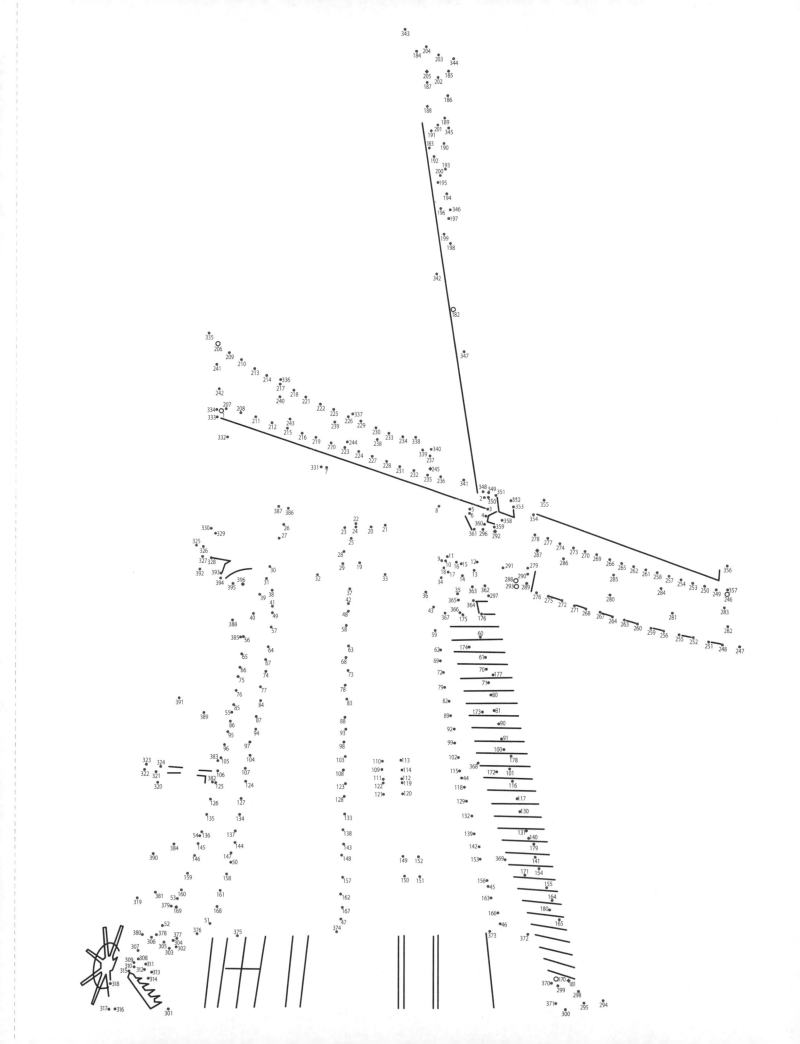

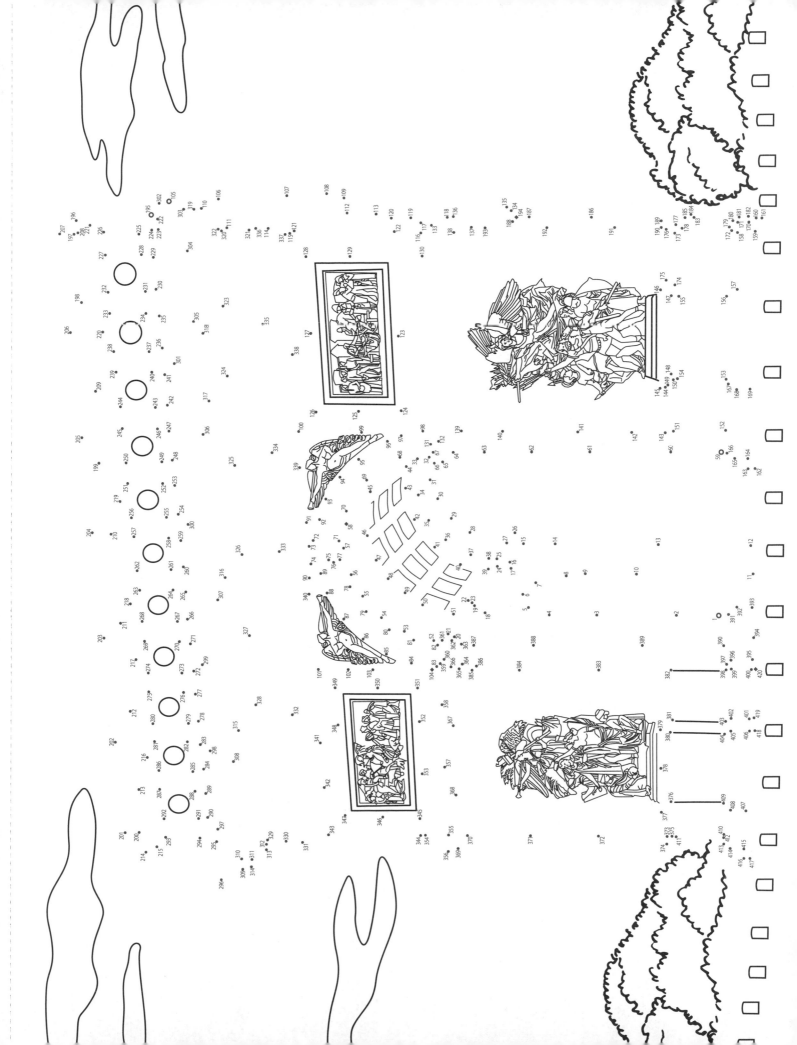

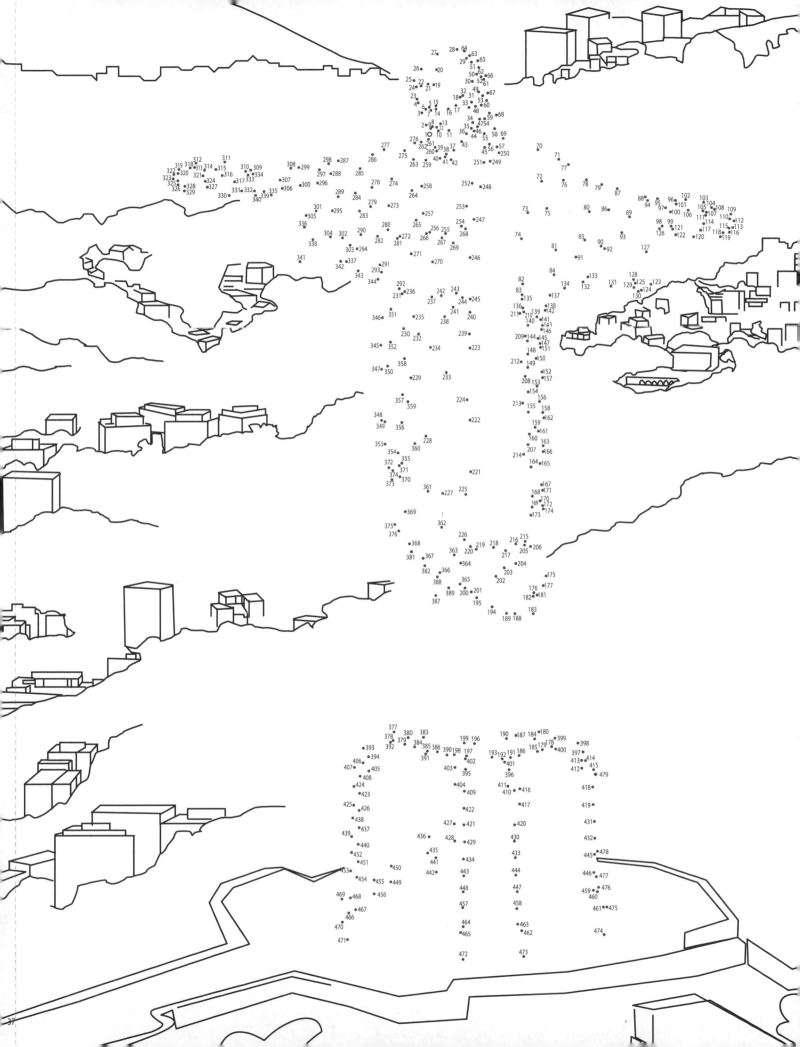

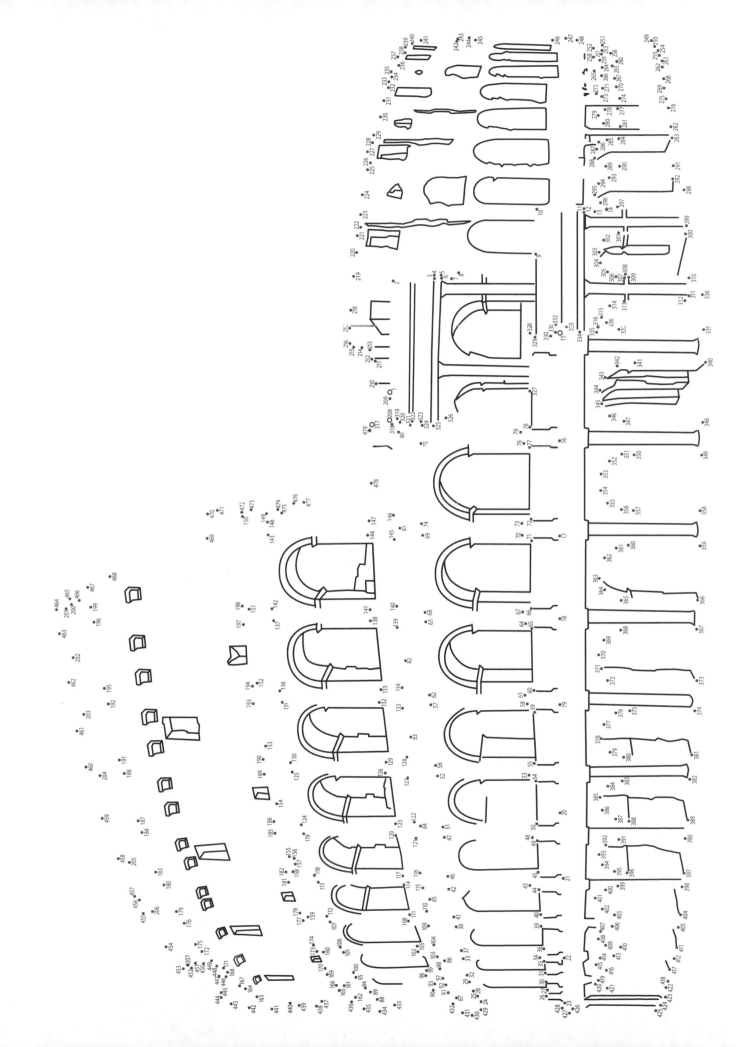

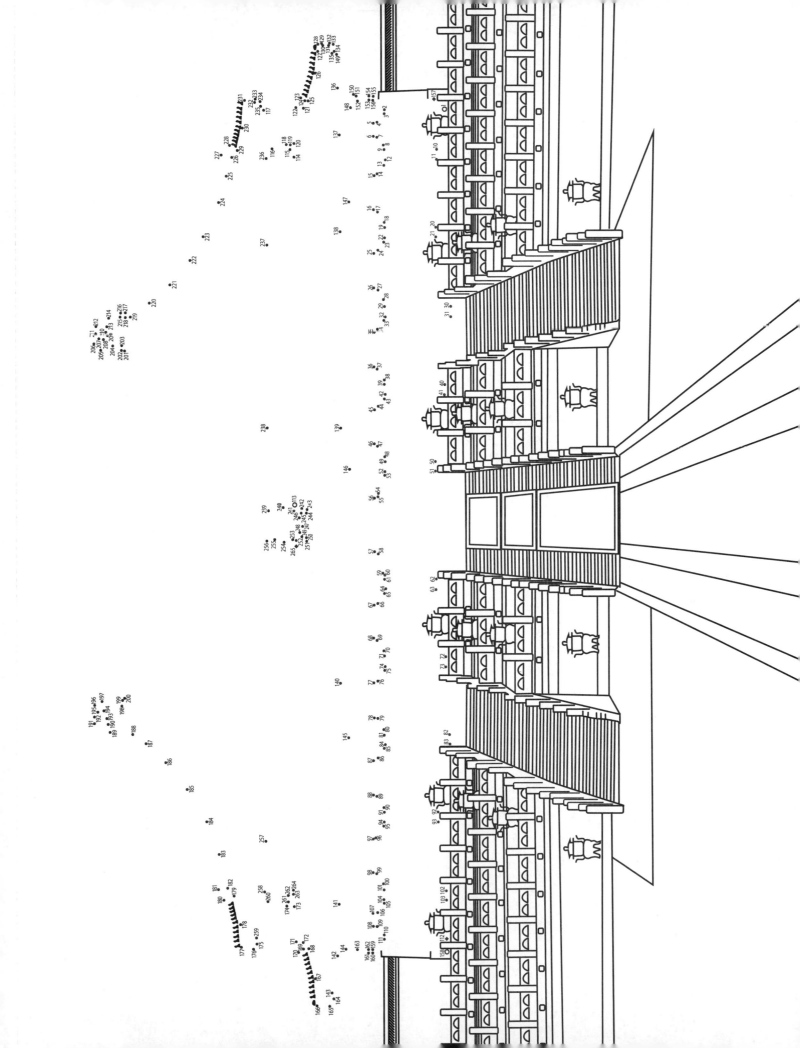

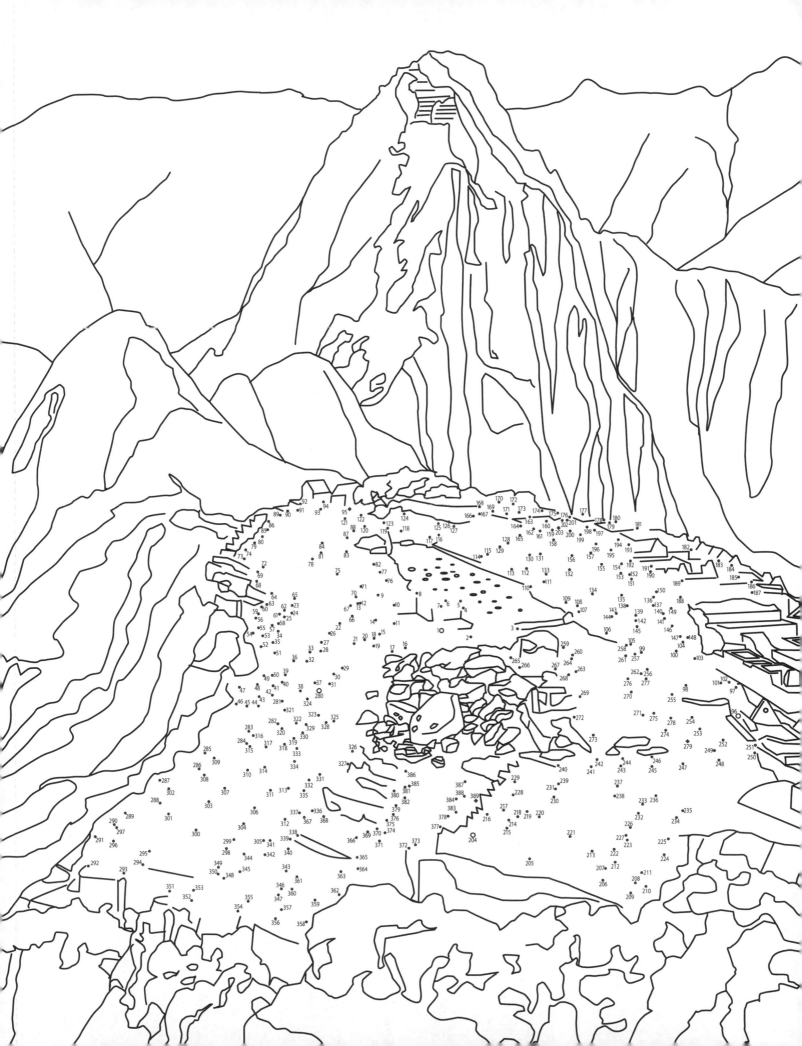

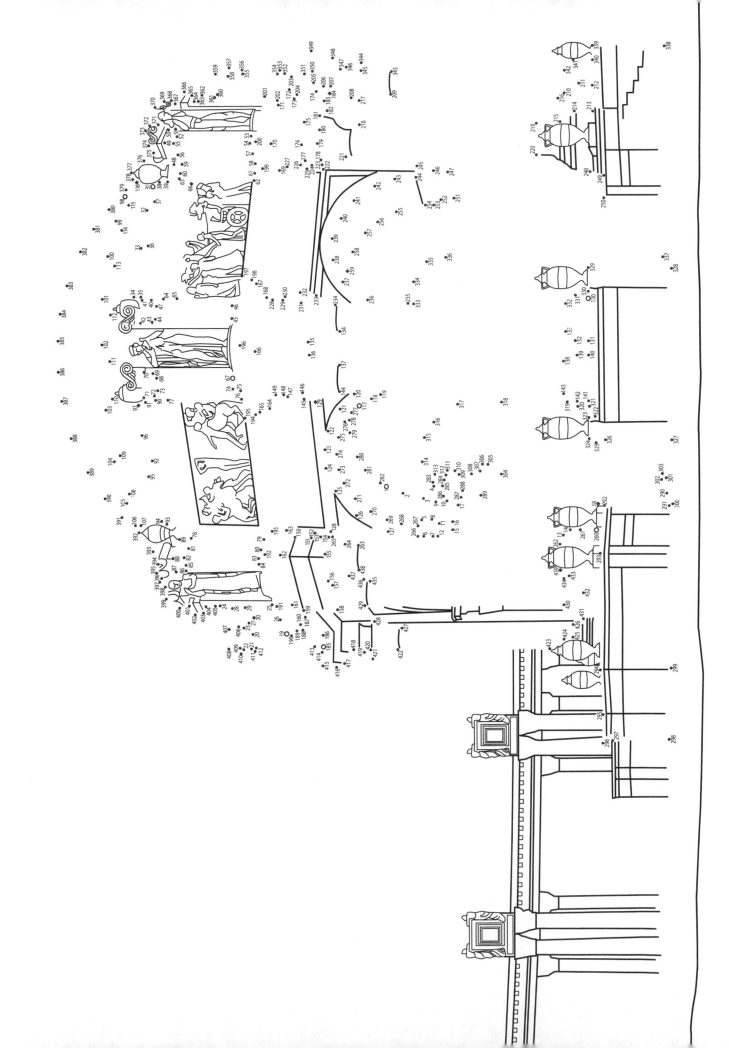

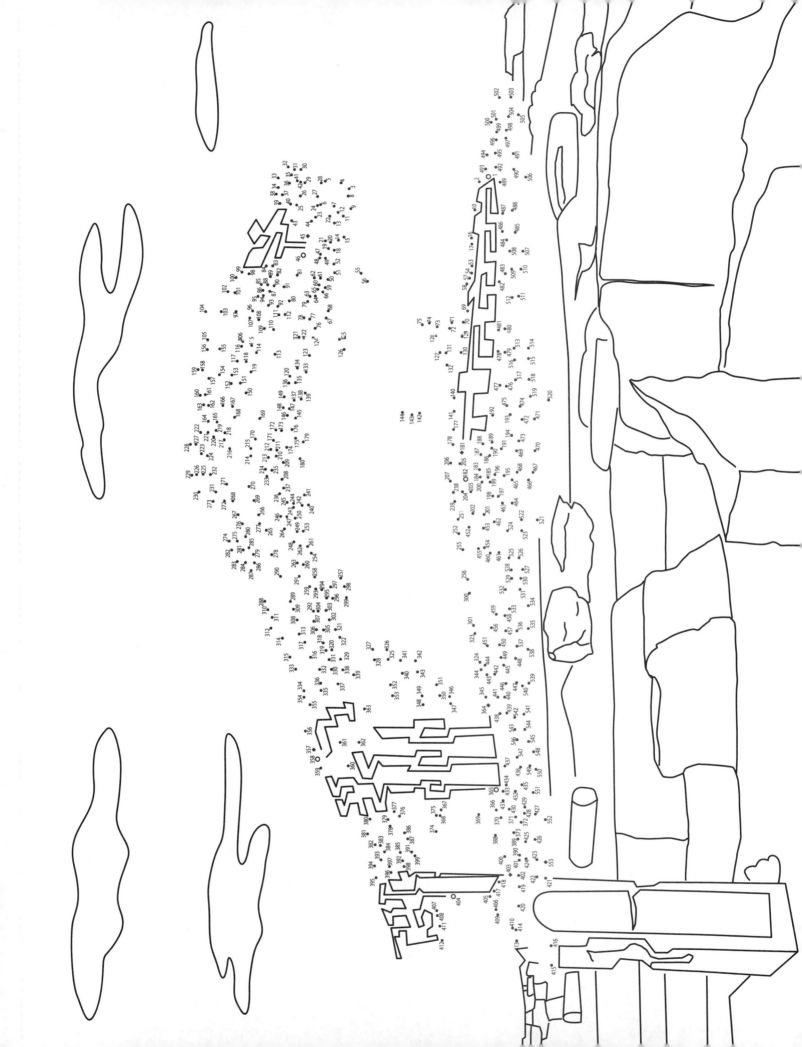

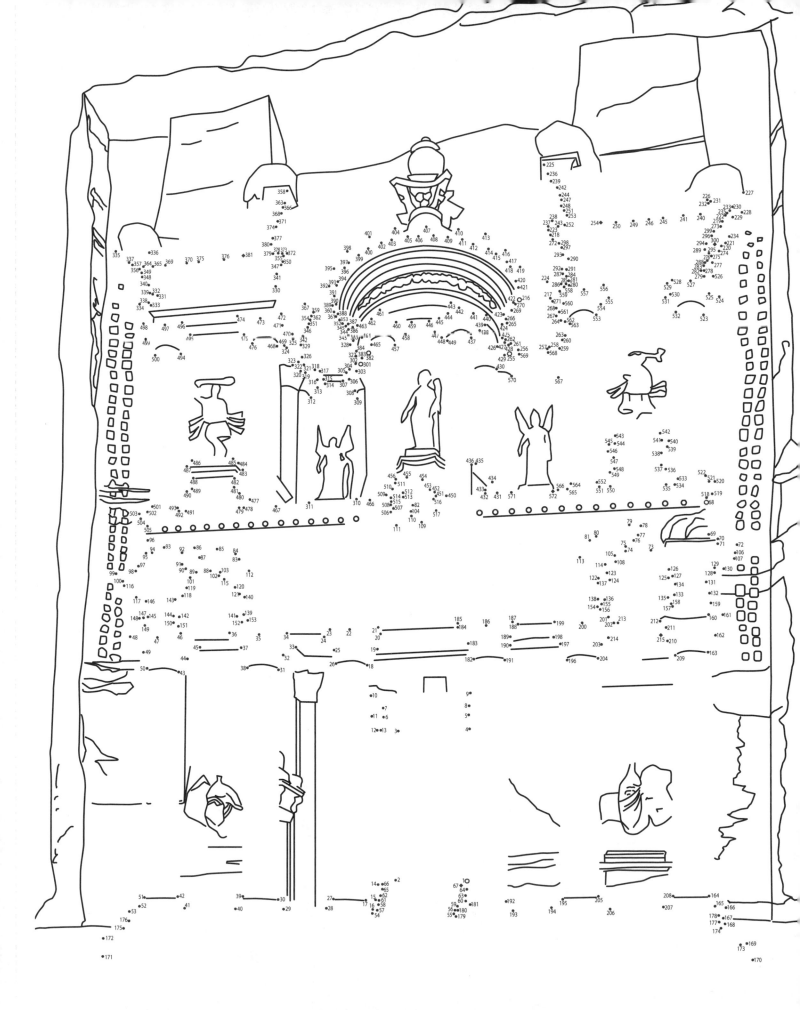

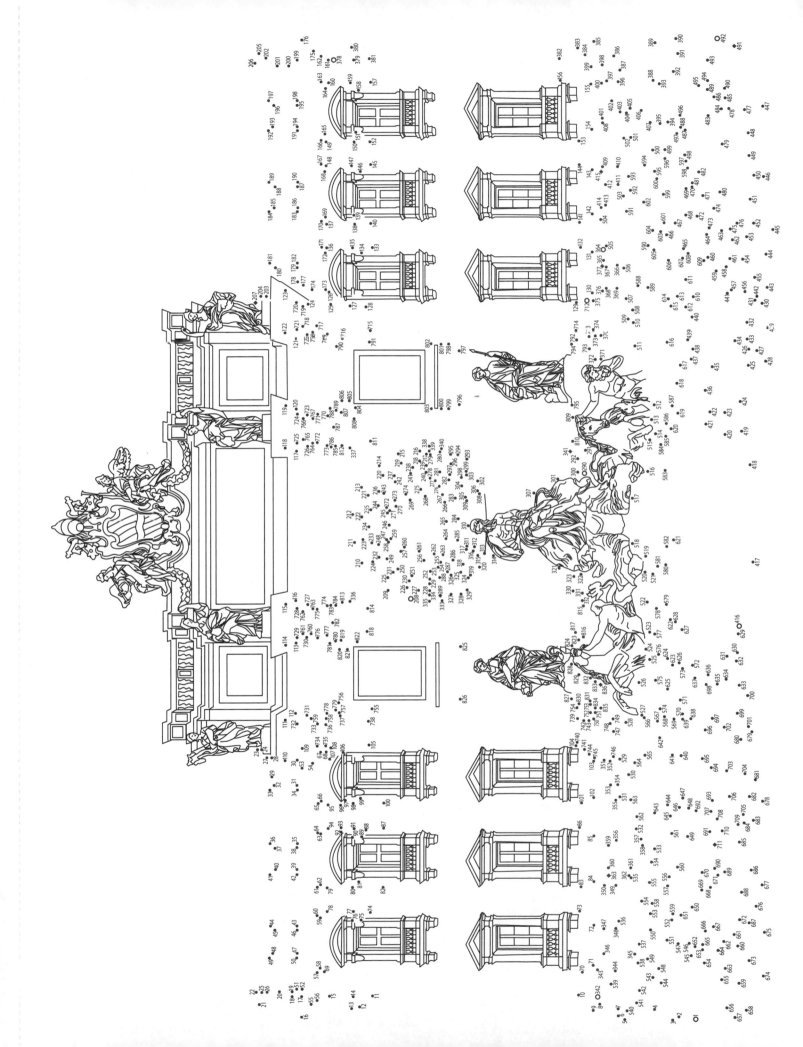

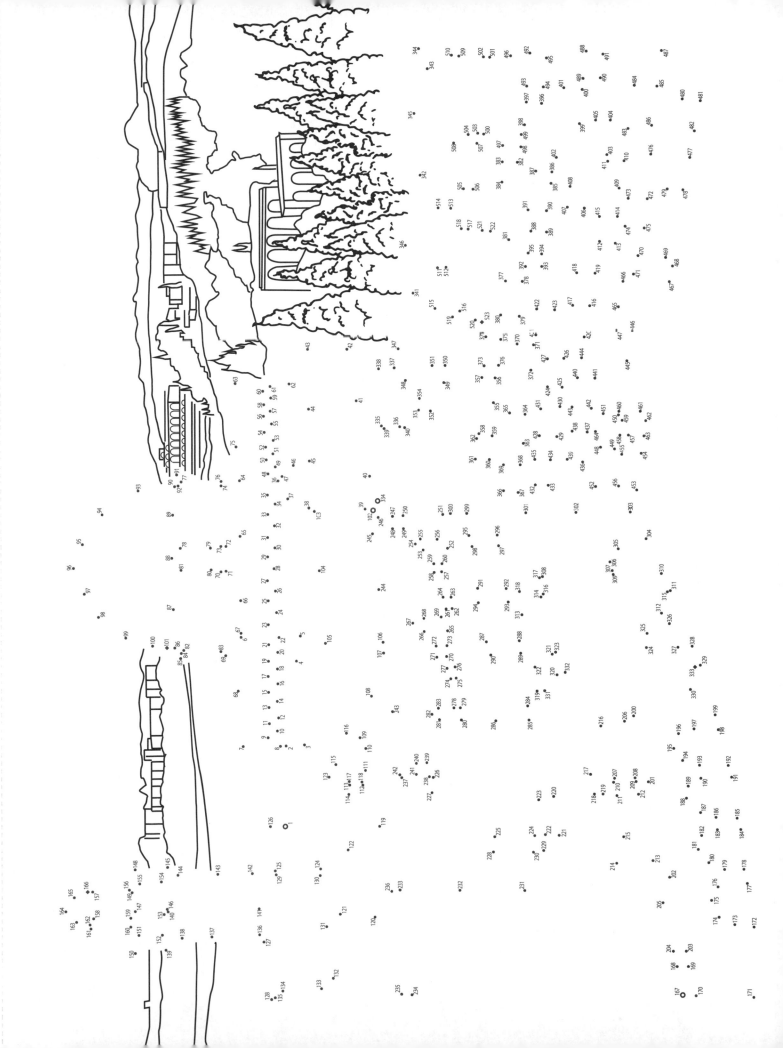

# ANSWER KEY

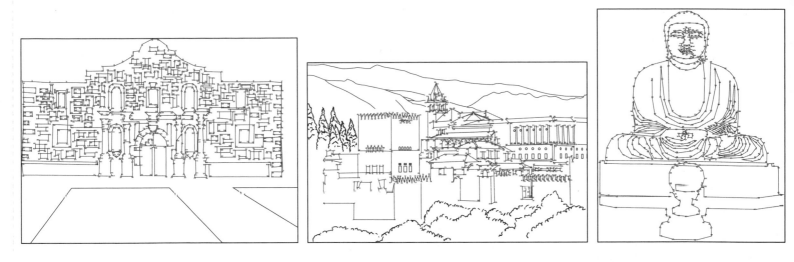

1. The Alamo - San Antonio, Texas, USA

2. Alhambra - Granada, Spaint

3. Amida Buddha - Kōtoku-in
Temple, Kamakura, Japan

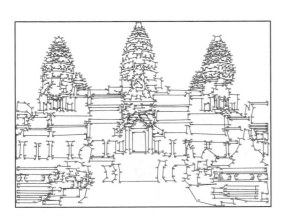

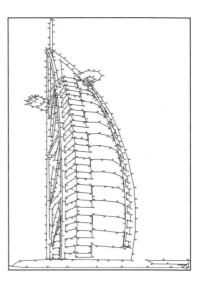

4. Angkor Wat -
Angkor, Siem Reap Province, Cambodia

5. Big Ben (Elizabeth Tower) -
London, United Kingdom

6. Burj Al Arab - Jumeirah, Dubai,
United Arab Emirates

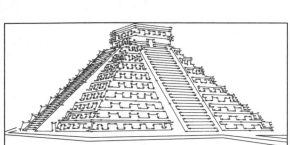

7. El Castillo, Chichen Itza -
Chichen Itza, Mexico

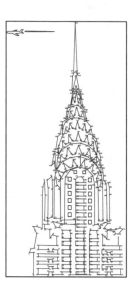

8. The Chrysler Building -
New York City, New York, USA

9. Moai - Ahu Akivi, Easter Island

10. The Eiffel Tower - Paris, France

11. The Empire State Building -
New York City, New York, USA

12. Grauman's Chinese Theatre -
Hollywood, Los Angeles, California, USA

13. The Great Sphinx of Giza -
Giza, Egypt

14. The Great Wall of China - China

15. Hagia Sophia -
Istanbul, Turkey

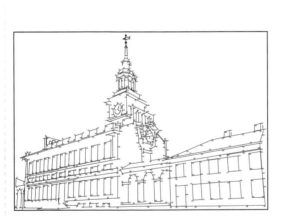

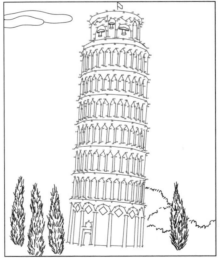

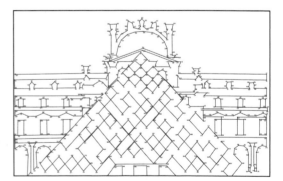

16. Independence Hall -
Philadelphia, Pennsylvania, USA

17. The Leaning Tower of Pisa -
Pisa, Italy

18. The Louvre Museum -
Paris, France

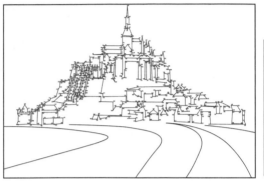

19. Le Mont-Saint-Michel -
Normandy, France

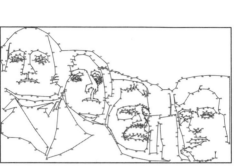

20. Mount Rushmore -
Pennington County, South Dakota, USA

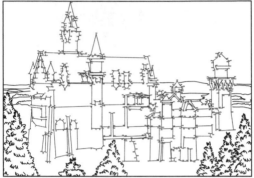

21. Neuschwanstein Castle -
Hohenschwangau, Germany

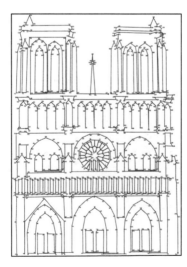

22. Notre-Dame Cathedral -
Paris, France

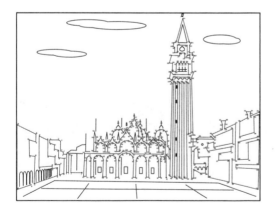

23. St Mark's Square - Venice, Italy

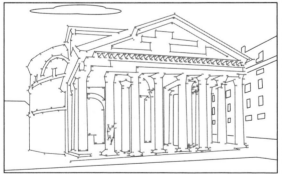

24. The Pantheon - Rome, Italy

25. Oia - Santorini, Greece

26. Sensō-ji Temple - Asakusa, Tokyo, Japan

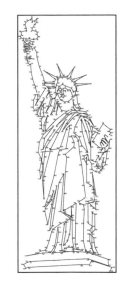

27. The Statue of Liberty -
New York City, New York, USA

28. Urnes Stave Church - Ornes, Norway

29. Saint Basil's Cathedral -
Moscow, Russia

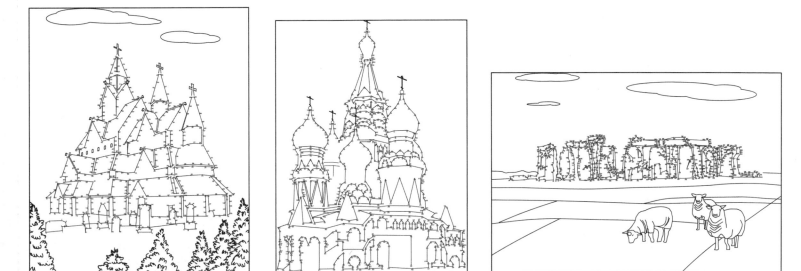

30. Stonehenge - Wiltshire, England

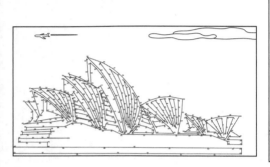

31. Sydney Opera House - Sydney, Australia

32. The Taj Mahal - Agra, India

33. Tower Bridge - London, United Kingdom

34. The White House - Washington, DC, USA

35. Windmills -
Kinderdijk, Netherlands

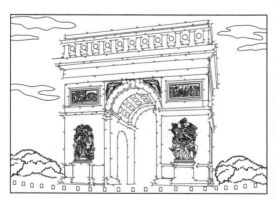

36. Arc de Triomphe - Paris, France

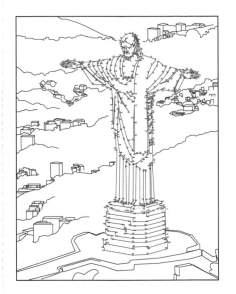

37. Christ the Redeemer -
Rio de Janeiro, Brazil

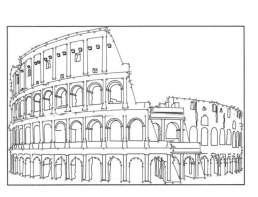

38. The Colosseum - Rome, Italy

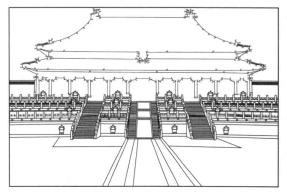

39. The Forbidden City - Beijing, China

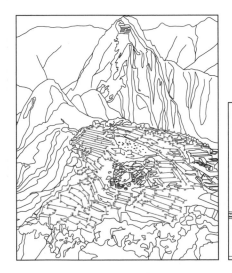

40. Machu Picchu -
Cuzco Region, Peru

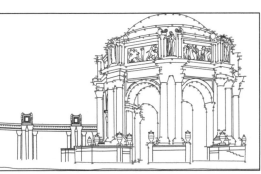

41. The Palace of Fine Arts -
San Francisco, California, USA

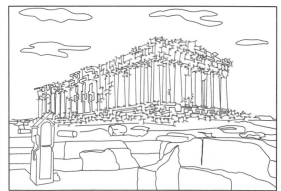

42. The Parthenon - Athens, Greece

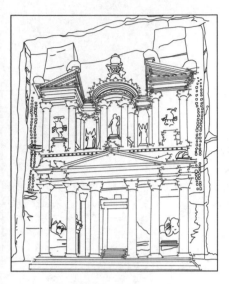

43. Al Khazneh - Petra, Jordan

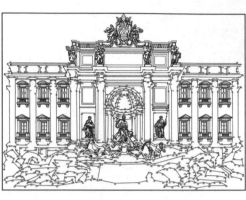

44. Trevi Fountain - Rome, Italy

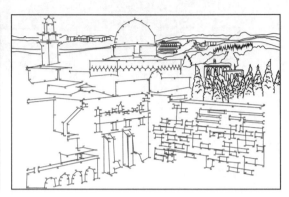

45. The Western Wall and The Dome of the Rock - Jerusalem